Apocalipsis cu figuris

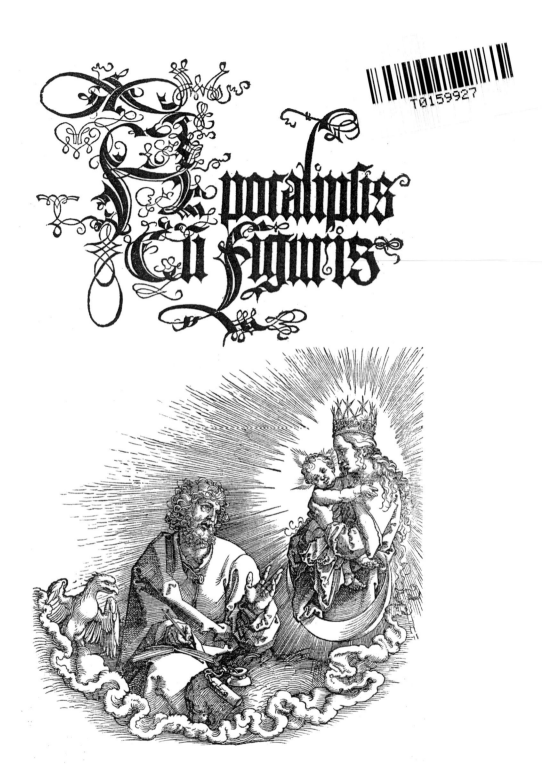

I. ST JOHN CAST INTO A VAT OF BOILING OIL BY THE EMPEROR DOMITIAN

St. John the apostle and evangelist was son of Zebedee, which had married
the third sister of our Lady to wife, and that was brother to St. James of Galicia.
This said 'John' signifieth as much as 'the grace of God,' and well might he have
such a name, for he had of our Lord four graces above the other apostles.
The first is that he was beloved of our Lord. The second was, that our Lord kept
to him his virginity like as St. Jerome saith, for he was at his wedding, and he
abode a clean virgin. The third is that our Lord made him to have much great
revelation and knowledge of his divinity, and of the finishing of the world,
like as it appeareth in the beginnings of his evangel, and in the Apocalypse.
The fourth grace is that our Lord committed to him in especial the keeping
of his sweet mother. He was, after the ascension of our Lord, in Jerusalem
with the apostles and others, and after that they were, by the ordinance of
the Holy Ghost, confirmed in the Christian faith by the universal world,
St. John came into Greece where he conversed and converted much people
and founded many churches in the Christian faith
as well by miracles as by doctrine.

In this time Domitian was Emperor of Rome, which made right great
persecutions unto Christian men, and did do take St. John, and did him to be
brought to Rome and made him to be cast into a vat or a ton full of hot oil in
the presence of the senators, of which he issued out, by the help of God,
more pure and more fair, without feeling of any more heat or chauffing,
than he entered in. After this that emperor saw that he ceased not to preach
the Christian faith, he sent him into exile unto an isle called Patmos.
There was St. John alone, and was visited of angels and governed;
there wrote he by the revelation of our Lord the
Apocalypse, which contained the secrets of holy church
and of the world to come.

FROM THE GOLDEN LEGEND BY JACOBUS DE VORAGINE (C. 1260),
ENGLISHED BY WILLIAM CAXTON (1483),
MODERNISED BY FREDERICK STARTRIDGE ELLIS (1900)

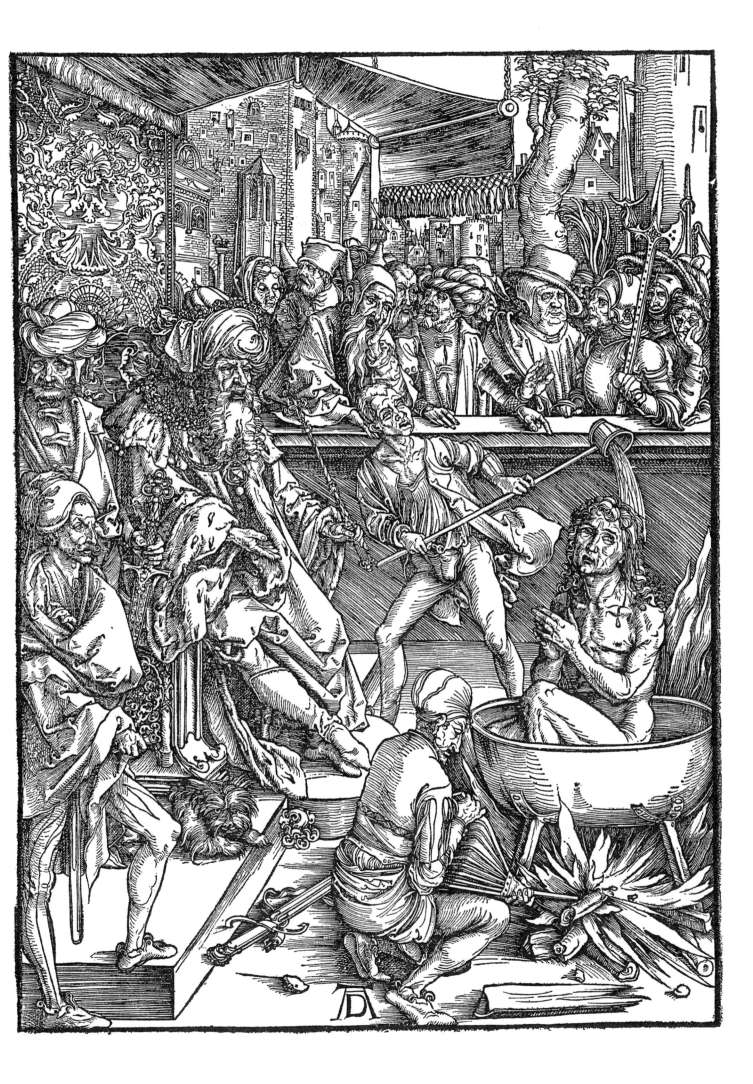

2. ST JOHN'S VISION OF THE SEVEN CANDLESTICKS

8 I am Alpha and Omega, the beginning and the ending, saith the Lord, which is,
and which was, and which is to come, the Almighty.

9 I John, who also am your brother, and companion in tribulation, and in the
kingdom and patience of Jesus Christ, was in the isle that is called Patmos,
for the word of God, and for the testimony of Jesus Christ.

10 I was in the Spirit on the Lord's day, and heard behind me a great voice,
as of a trumpet,

11 Saying, I am Alpha and Omega, the first and the last: and, What thou seest,
write in a book, and send it unto the seven churches which are in Asia;
unto Ephesus, and unto Smyrna, and unto Pergamos, and unto Thyatira,
and unto Sardis, and unto Philadelphia, and unto Laodicea.

12 And I turned to see the voice that spake with me. And being turned,
I saw seven golden candlesticks;

13 And in the midst of the seven candlesticks one like unto the Son of man,
clothed with a garment down to the foot, and girt about the paps
with a golden girdle.

14 His head and his hairs were white like wool, as white as snow;
and his eyes were as a flame of fire;

15 And his feet like unto fine brass, as if they burned in a furnace;
and his voice as the sound of many waters.

16 And he had in his right hand seven stars: and out of his mouth went
a sharp two-edged sword: and his countenance was
as the sun shineth in his strength.

17 And when I saw him, I fell at his feet as dead. And he laid his right hand
upon me, saying unto me, Fear not; I am the first and the last:

18 I am he that liveth, and was dead; and, behold, I am alive for evermore, Amen;
and have the keys of hell and of death.

19 Write the things which thou hast seen, and the things which are,
and the things which shall be hereafter;

20 The mystery of the seven stars which thou sawest in my right hand,
and the seven golden candlesticks. The seven stars are the angels of
the seven churches: and the seven candlesticks which thou sawest
are the seven churches.

REVELATION, CHAPTER I, VERSES 8-20

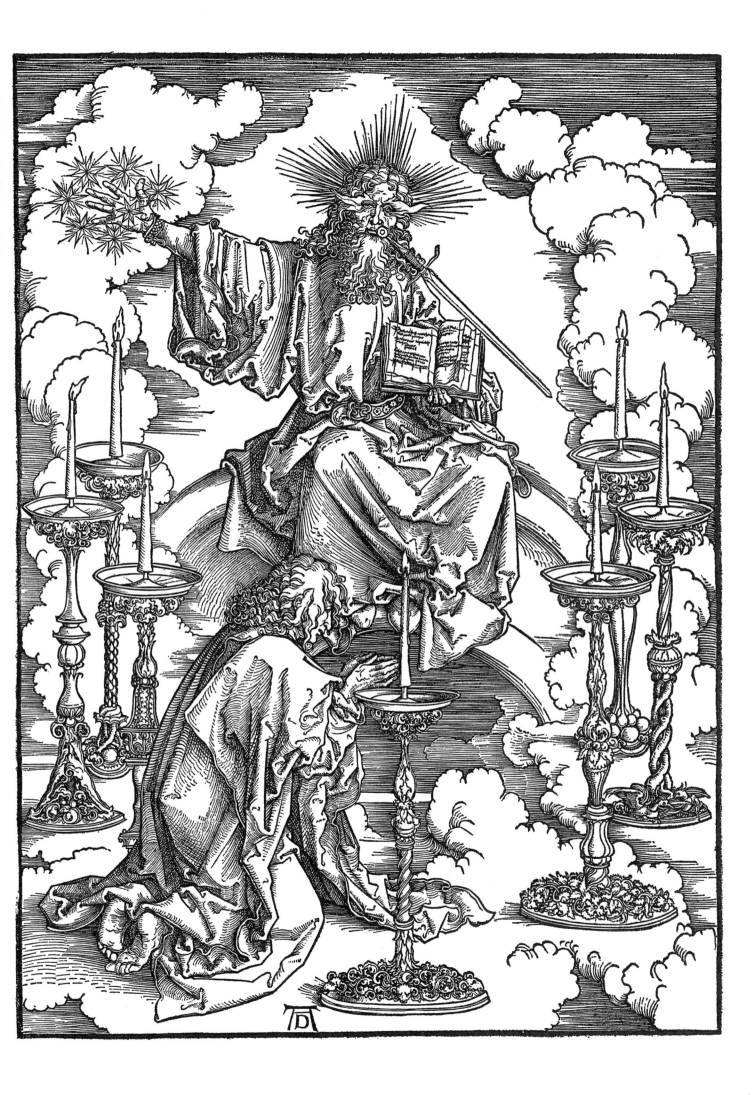

1 After this I looked, and, behold, a door was opened in heaven: and the first
voice which I heard was as it were of a trumpet talking with me; which said,
Come up hither, and I will shew thee things which must be hereafter.
2 And immediately I was in the spirit: and, behold, a throne was set in heaven,
and one sat on the throne.
3 And he that sat was to look upon like a jasper and a sardine stone: and there
was a rainbow round about the throne, in sight like unto an emerald.
4 And round about the throne were four and twenty seats: and upon the seats
I saw four and twenty elders sitting, clothed in white raiment;
and they had on their heads crowns of gold.
5 And out of the throne proceeded lightnings and thunderings and voices:
and there were seven lamps of fire burning before the throne,
which are the seven Spirits of God.
6 And before the throne there was a sea of glass like unto crystal:
and in the midst of the throne, and round about the throne,
were four beasts full of eyes before and behind.
7 And the first beast was like a lion, and the second beast like a calf, and the third
beast had a face as a man, and the fourth beast was like a flying eagle.
8 And the four beasts had each of them six wings about him; and they were
full of eyes within: and they rest not day and night, saying,
Holy, holy, holy, Lord God Almighty, which was, and is, and is to come.
9 And when those beasts give glory and honour and thanks to him
that sat on the throne, who liveth for ever and ever,
10 The four and twenty elders fall down before him that sat on the throne,
and worship him that liveth for ever and ever, and cast their crowns
before the throne, saying,
11 Thou art worthy, O Lord, to receive glory and honour and power: for thou hast
created all things, and for thy pleasure they are and were created.

REVELATION, CHAPTER 4

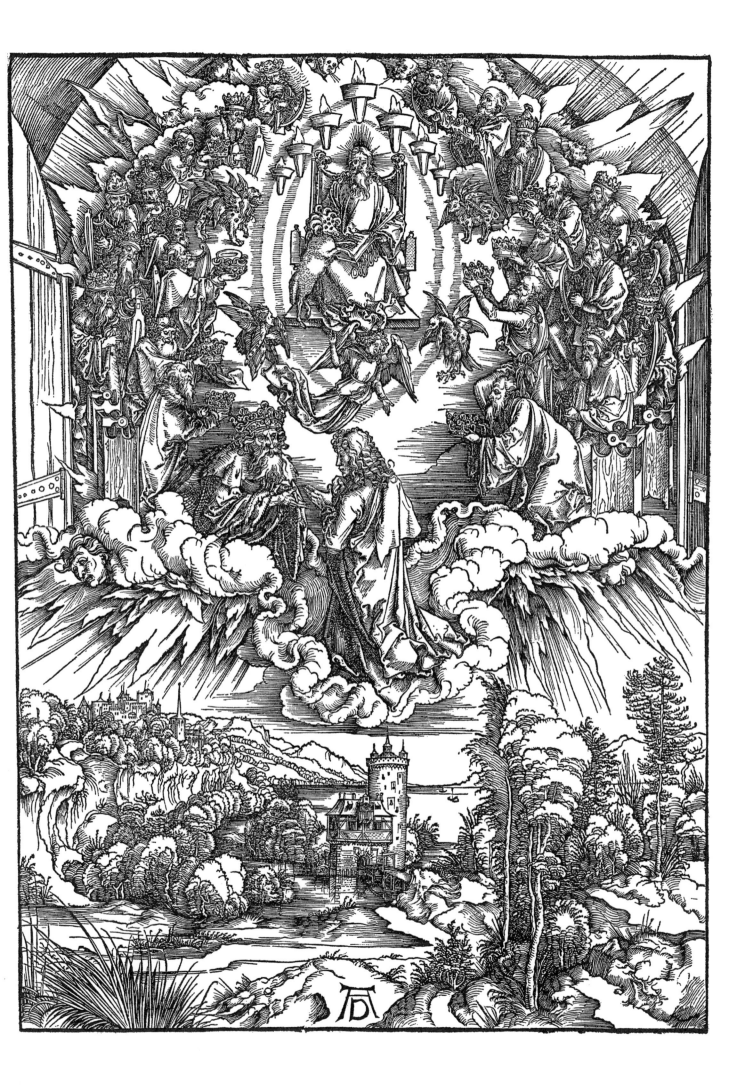

4. THE FOUR HORSEMEN OF THE APOCALYPSE

1 And I saw in the right hand of him that sat on the throne a book written
within and on the backside, sealed with seven seals.

2 And I saw a strong angel proclaiming with a loud voice, Who is worthy to
open the book, and to loose the seals thereof?

3 And no man in heaven, nor in earth, neither under the earth, was able to
open the book, neither to look thereon.

4 And I wept much, because no man was found worthy to open and to read
the book, neither to look thereon.

5 And one of the elders saith unto me, Weep not: behold, the Lion of the tribe of Judah,
the Root of David, hath prevailed to open the book,
and to loose the seven seals thereof.

6 And I beheld, and, lo, in the midst of the throne and of the four beasts, and in the
midst of the elders, stood a Lamb as it had been slain, having seven horns and
seven eyes, which are the seven Spirits of God sent forth into all the earth.

7 And he came and took the book out of the right hand of him that sat upon the throne.

1 And I saw when the Lamb opened one of the seals, and I heard, as it were
the noise of thunder, one of the four beasts saying,
Come and see.

2 And I saw, and behold a white horse: and he that sat on him had a bow; and a
crown was given unto him: and he went forth conquering, and to conquer.

3 And when he had opened the second seal, I heard the second beast say,
Come and see.

4 And there went out another horse that was red: and power was given to him
that sat thereon to take peace from the earth, and that they should kill
one another: and there was given unto him a great sword.

5 And when he had opened the third seal, I heard the third beast say,
Come and see.
And I beheld, and lo a black horse; and he that sat on him had
a pair of balances in his hand.

6 And I heard a voice in the midst of the four beasts say, A measure of wheat for a penny,
and three measures of barley for a penny; and see thou hurt not the oil and the wine.

7 And when he had opened the fourth seal, I heard the voice of the fourth beast say,
Come and see.

8 And I looked, and behold a pale horse: and his name that sat on him was Death,
and Hell followed with him. And power was given unto them over the fourth
part of the earth, to kill with sword, and with hunger, and with death,
and with the beasts of the earth.

REVELATION, CHAPTER 5, VERSES 1-7, AND CHAPTER 6, VERSES 1-8

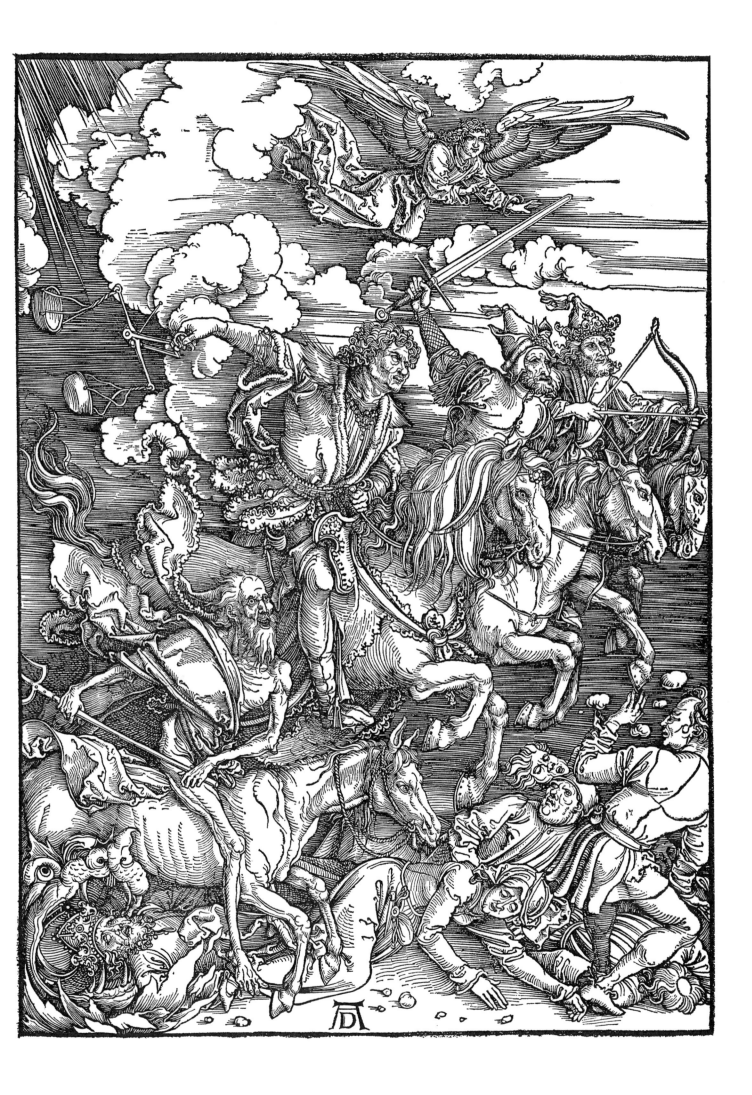

9 And when he had opened the fifth seal, I saw under the altar the souls of them
that were slain for the word of God, and for the testimony which they held:
10 And they cried with a loud voice, saying, How long, O Lord, holy and true,
dost thou not judge and avenge our blood on them that dwell on the earth?
11 And white robes were given unto every one of them; and it was said unto them,
that they should rest yet for a little season, until their fellow servants also and
their brethren, that should be killed as they were, should be fulfilled.
12 And I beheld when he had opened the sixth seal, and, lo, there was
a great earthquake; and the sun became black as sackcloth of hair,
and the moon became as blood;
13 And the stars of heaven fell unto the earth, even as a fig tree casteth
her untimely figs, when she is shaken of a mighty wind.
14 And the heaven departed as a scroll when it is rolled together;
and every mountain and island were moved out of their places.
15 And the kings of the earth, and the great men, and the rich men,
and the chief captains, and the mighty men, and every bondman,
and every free man, hid themselves in the dens
and in the rocks of the mountains;
16 And said to the mountains and rocks, Fall on us, and hide us from the face
of him that sitteth on the throne, and from the wrath of the Lamb:
17 For the great day of his wrath is come; and who shall be able to stand?

REVELATION, CHAPTER 6, VERSES 9-17

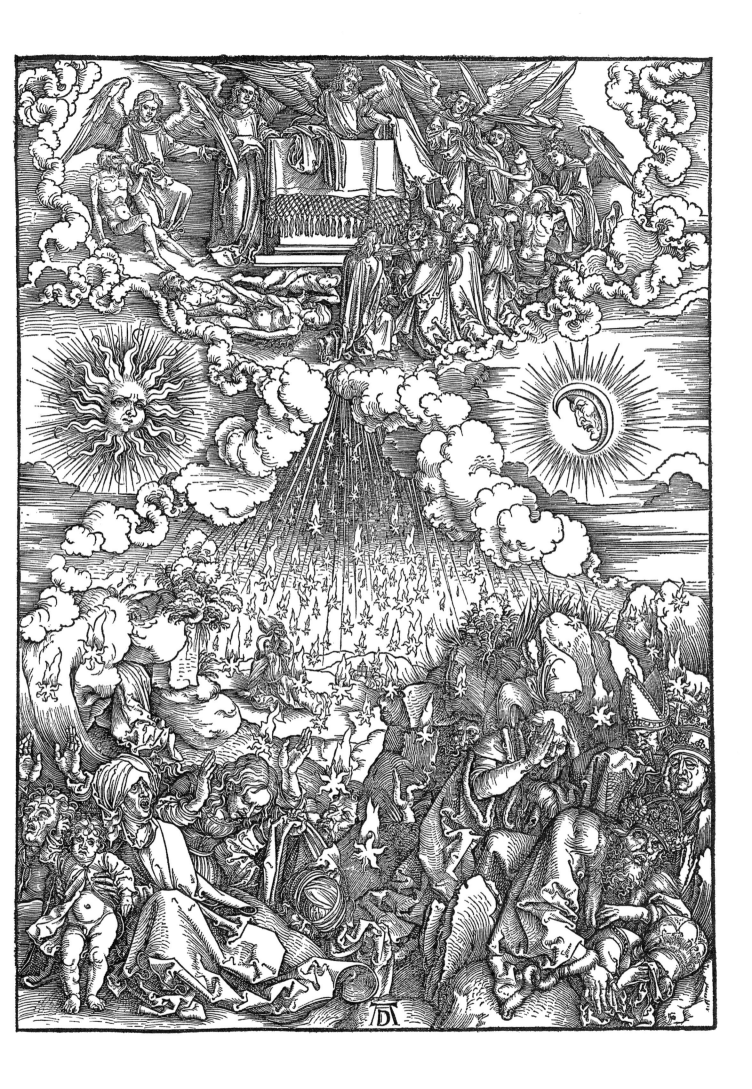

6. FOUR ANGELS HOLDING BACK THE WINDS, AND THE MARKING OF THE ELECT

1 And after these things I saw four angels standing on the four corners of the earth, holding the four winds of the earth, that the wind should not blow on the earth, nor on the sea, nor on any tree.

2 And I saw another angel ascending from the east, having the seal of the living God: and he cried with a loud voice to the four angels, to whom it was given to hurt the earth and the sea,

3 Saying, Hurt not the earth, neither the sea, nor the trees, till we have sealed the servants of our God in their foreheads.

4 And I heard the number of them which were sealed: and there were sealed an hundred and forty and four thousand of all the tribes of the children of Israel.

5 Of the tribe of Juda were sealed twelve thousand. Of the tribe of Reuben were sealed twelve thousand. Of the tribe of Gad were sealed twelve thousand.

6 Of the tribe of Aser were sealed twelve thousand. Of the tribe of Nephthalim were sealed twelve thousand. Of the tribe of Manasses were sealed twelve thousand.

7 Of the tribe of Simeon were sealed twelve thousand. Of the tribe of Levi were sealed twelve thousand. Of the tribe of Issachar were sealed twelve thousand.

8 Of the tribe of Zabulon were sealed twelve thousand. Of the tribe of Joseph were sealed twelve thousand. Of the tribe of Benjamin were sealed twelve thousand.

REVELATION, CHAPTER 7, VERSES 1-8

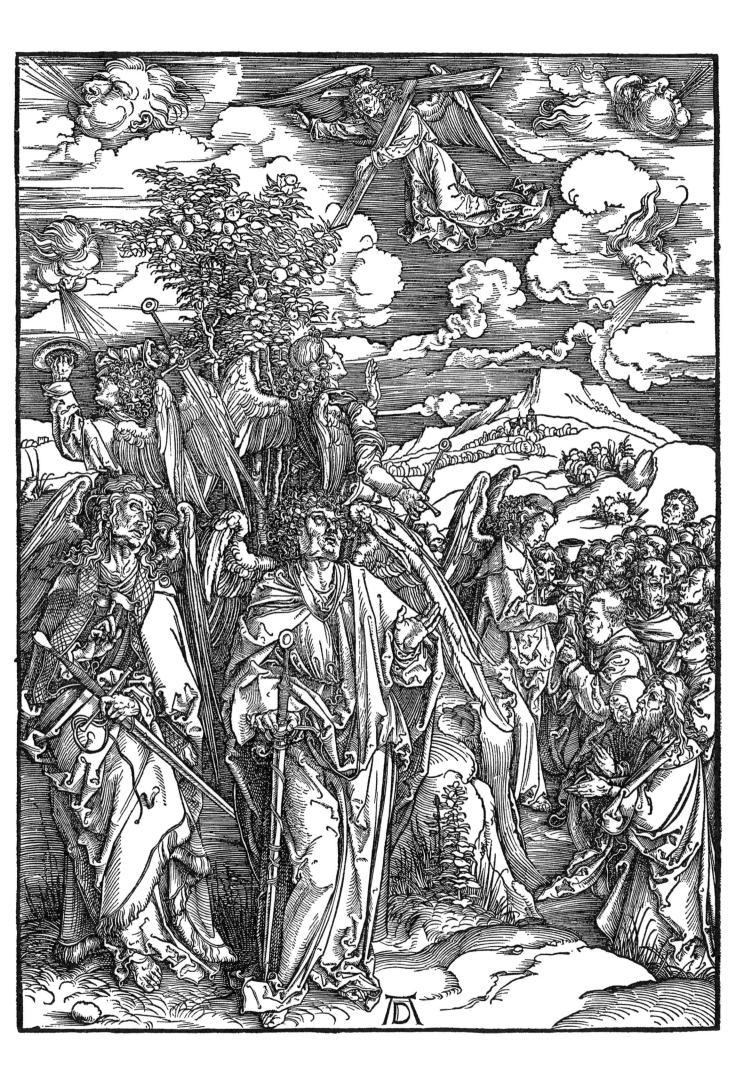

9 After this I beheld, and, lo, a great multitude, which no man could number, of
all nations, and kindreds, and people, and tongues, stood before the throne,
and before the Lamb, clothed with white robes, and palms in their hands;
10 And cried with a loud voice, saying, Salvation to our God which sitteth
upon the throne, and unto the Lamb.
11 And all the angels stood round about the throne, and about the elders and the
four beasts, and fell before the throne on their faces, and worshipped God,
12 Saying, Amen: Blessing, and glory, and wisdom, and thanksgiving, and honour,
and power, and might, be unto our God for ever and ever. Amen.
13 And one of the elders answered, saying unto me, What are these which are
arrayed in white robes? and whence came they?
14 And I said unto him, Sir, thou knowest. And he said to me, These are
they which came out of great tribulation, and have washed their robes,
and made them white in the blood of the Lamb.
15 Therefore are they before the throne of God, and serve him day and night in
his temple: and he that sitteth on the throne shall dwell among them.
16 They shall hunger no more, neither thirst any more; neither shall the sun light
on them, nor any heat.
17 For the Lamb which is in the midst of the throne shall feed them, and shall
lead them unto living fountains of waters: and God shall wipe away
all tears from their eyes.

REVELATION, CHAPTER 7, VERSES 9-17

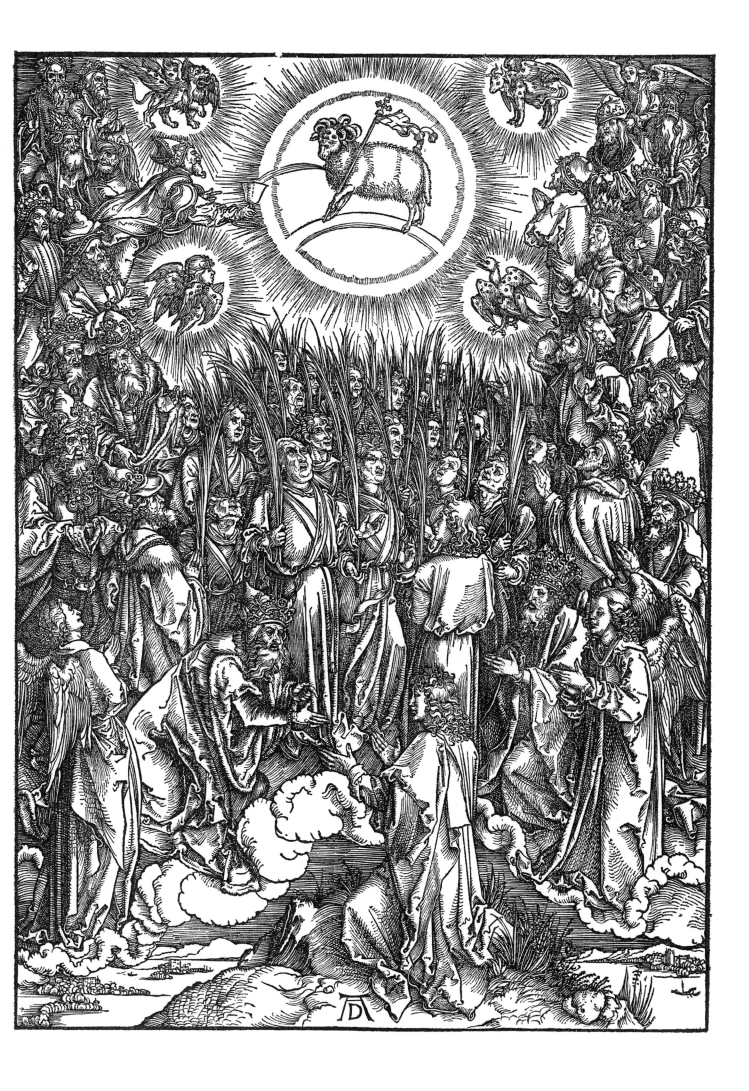

8. THE OPENING OF THE SEVENTH SEAL AND THE EAGLE CRYING 'WOE'

1 And when he had opened the seventh seal, there was silence in heaven
about the space of half an hour.
2 And I saw the seven angels which stood before God; and to them were given seven trumpets.
3 And another angel came and stood at the altar, having a golden censer; and there
was given unto him much incense, that he should offer it with the prayers
of all saints upon the golden altar which was before the throne.
4 And the smoke of the incense, which came with the prayers of the saints,
ascended up before God out of the angel's hand.
5 And the angel took the censer, and filled it with fire of the altar, and cast it into the earth:
and there were voices, and thunderings, and lightnings, and an earthquake.
6 And the seven angels which had the seven trumpets prepared themselves to sound.
7 The first angel sounded, and there followed hail and fire mingled with blood,
and they were cast upon the earth: and the third part of trees was burnt up,
and all green grass was burnt up.
8 And the second angel sounded, and as it were a great mountain burning with fire
was cast into the sea: and the third part of the sea became blood;
9 And the third part of the creatures which were in the sea, and had life, died;
and the third part of the ships were destroyed.
10 And the third angel sounded, and there fell a great star from heaven,
burning as it were a lamp, and it fell upon the third part of the rivers,
and upon the fountains of waters;
11 And the name of the star is called Wormwood: and the third part of the waters
became wormwood; and many men died of the waters, because they were made bitter.
12 And the fourth angel sounded, and the third part of the sun was smitten,
and the third part of the moon, and the third part of the stars;
so as the third part of them was darkened, and the day
shone not for a third part of it, and the night likewise.
13 And I beheld, and heard an angel flying through the midst of heaven, saying with
a loud voice, Woe, woe, woe, to the inhabiters of the earth by reason of the other
voices of the trumpet of the three angels, which are yet to sound!
1 And the fifth angel sounded, and I saw a star fall from heaven unto the earth:
and to him was given the key of the bottomless pit.
2 And he opened the bottomless pit; and there arose a smoke out of the pit, as the smoke of
a great furnace; and the sun and the air were darkened by reason of the smoke of the pit.
3 And there came out of the smoke locusts upon the earth: and unto them
was given power, as the scorpions of the earth have power.

REVELATION, CHAPTER 8, VERSES 1-13, AND CHAPTER 9, VERSES 1-3

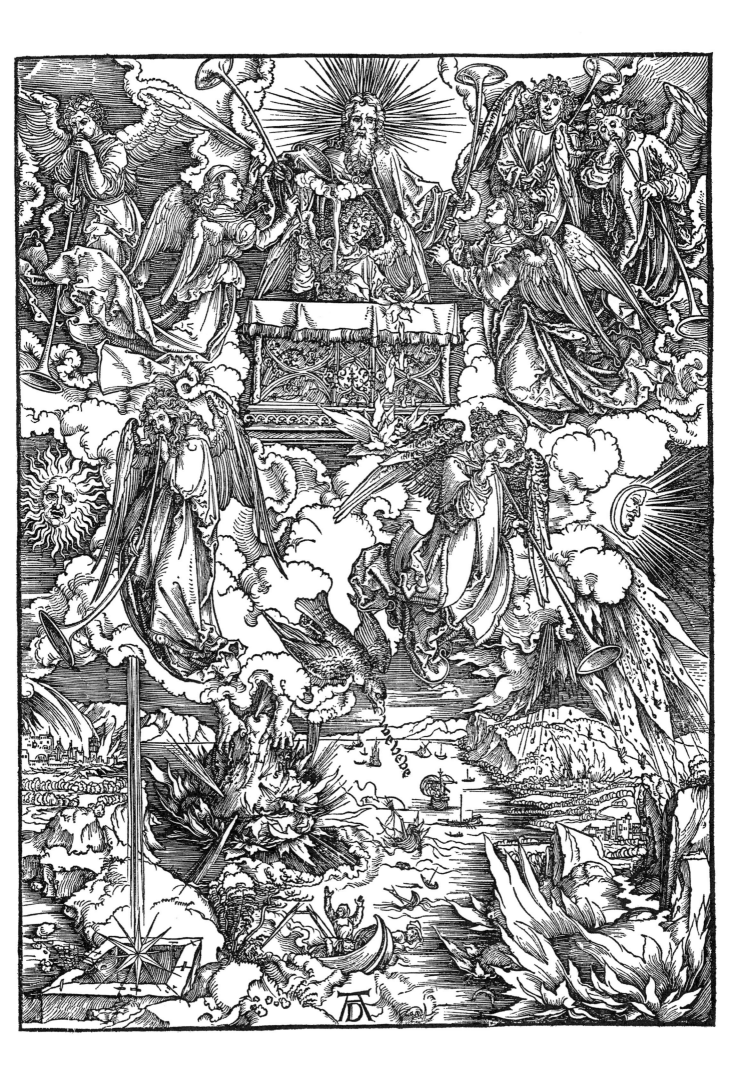

9. THE FOUR ANGELS OF DEATH

12 One woe is past; and, behold, there come two woes more hereafter.

13 And the sixth angel sounded, and I heard a voice from the four horns
of the golden altar which is before God,

14 Saying to the sixth angel which had the trumpet, Loose the four angels
which are bound in the great river Euphrates.

15 And the four angels were loosed, which were prepared for an hour, and a day,
and a month, and a year, for to slay the third part of men.

16 And the number of the army of the horsemen were two hundred thousand
thousand: and I heard the number of them.

17 And thus I saw the horses in the vision, and them that sat on them, having
breastplates of fire, and of jacinth, and brimstone: and the heads of the
horses were as the heads of lions; and out of their mouths issued
fire and smoke and brimstone.

18 By these three was the third part of men killed, by the fire, and by the smoke,
and by the brimstone, which issued out of their mouths.

19 For their power is in their mouth, and in their tails: for their tails were like
unto serpents, and had heads, and with them they do hurt.

20 And the rest of the men which were not killed by these plagues yet repented
not of the works of their hands, that they should not worship devils, and
idols of gold, and silver, and brass, and stone, and of wood:
which neither can see, nor hear, nor walk:

21 Neither repented they of their murders, nor of their sorceries,
nor of their fornication, nor of their thefts.

REVELATION, CHAPTER 9, VERSES 12-21

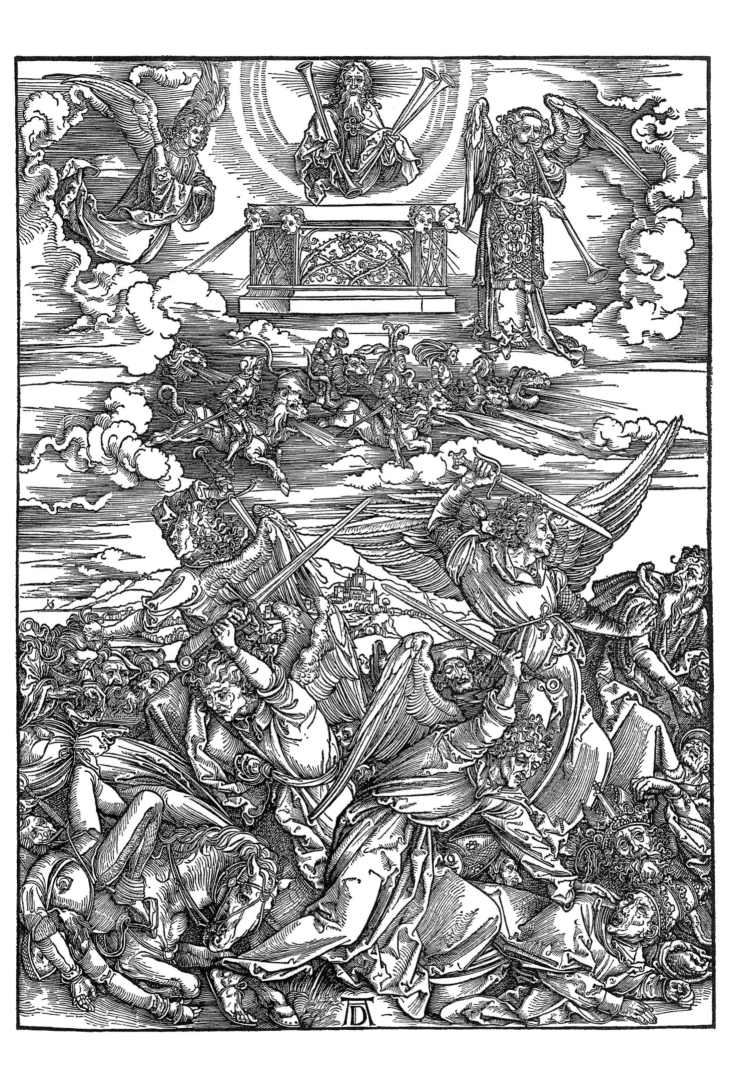

10. ST JOHN EATING THE BOOK

1 And I saw another mighty angel come down from heaven, clothed with a cloud:
and a rainbow was upon his head, and his face was as it were the sun,
and his feet as pillars of fire:
2 And he had in his hand a little book open: and he set his right foot upon the sea,
and his left foot on the earth,
3 And cried with a loud voice, as when a lion roareth: and when he had cried,
seven thunders uttered their voices.
4 And when the seven thunders had uttered their voices, I was about to write:
and I heard a voice from heaven saying unto me, Seal up those things which
the seven thunders uttered, and write them not.
5 And the angel which I saw stand upon the sea and upon the earth lifted up
his hand to heaven,
6 And sware by him that liveth for ever and ever, who created heaven, and the
things that therein are, and the earth, and the things that therein are, and the sea,
and the things which are therein, that there should be time no longer:
7 But in the days of the voice of the seventh angel, when he shall begin to sound,
the mystery of God should be finished, as he hath declared to his servants
the prophets.
8 And the voice which I heard from heaven spake unto me again, and said,
Go and take the little book which is open in the hand of the angel
which standeth upon the sea and upon the earth.
9 And I went unto the angel, and said unto him, Give me the little book.
And he said unto me, Take it, and eat it up; and it shall make thy belly bitter,
but it shall be in thy mouth sweet as honey.
10 And I took the little book out of the angel's hand, and ate it up; and it was in
my mouth sweet as honey: and as soon as I had eaten it, my belly was bitter.
11 And he said unto me, Thou must prophesy again before many peoples,
and nations, and tongues, and kings.

REVELATION, CHAPTER 10

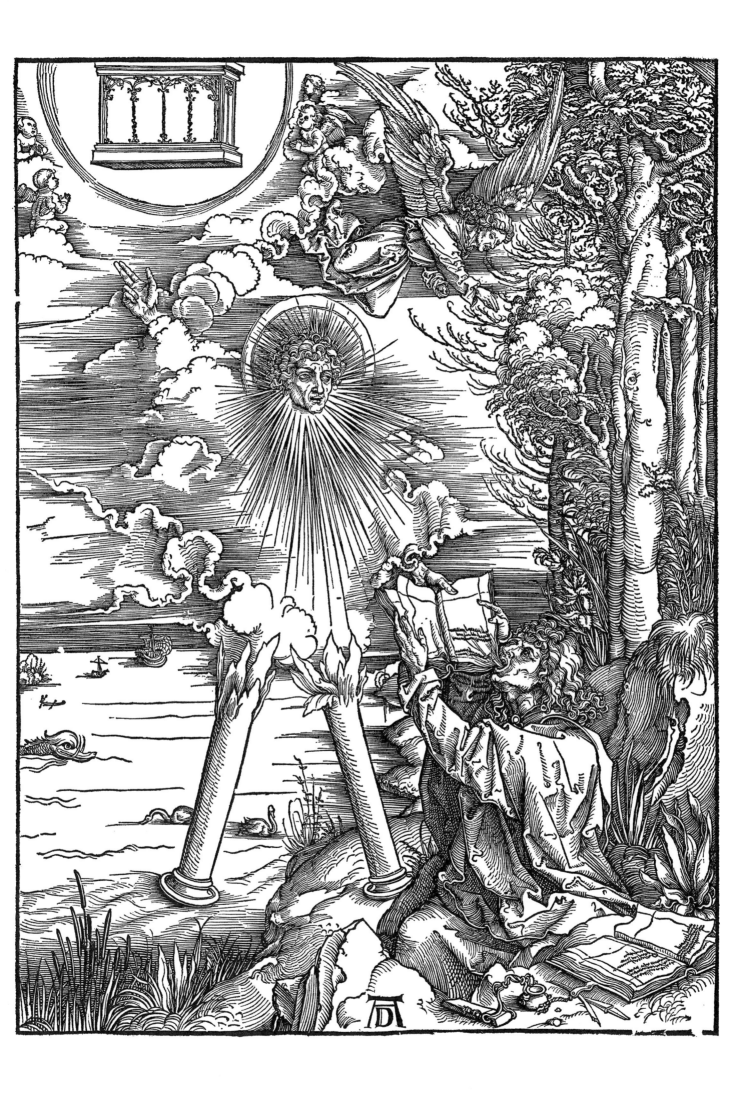

11. THE WOMAN OF THE APOCALYPSE AND THE SEVEN-HEADED DRAGON

1 And there appeared a great wonder in heaven; a woman clothed with the sun,
and the moon under her feet, and upon her head a crown of twelve stars:

2 And she being with child cried, travailing in birth, and pained to be delivered.

3 And there appeared another wonder in heaven; and behold a great red dragon,
having seven heads and ten horns, and seven crowns upon his heads.

4 And his tail drew the third part of the stars of heaven, and did cast them to the
earth: and the dragon stood before the woman which was ready to be delivered,
for to devour her child as soon as it was born.

5 And she brought forth a man child, who was to rule all nations with a rod of
iron: and her child was caught up unto God, and to his throne.

6 And the woman fled into the wilderness, where she hath a place prepared of
God, that they should feed her there a thousand two hundred and
threescore days.

REVELATION, CHAPTER 12, VERSES 1-6

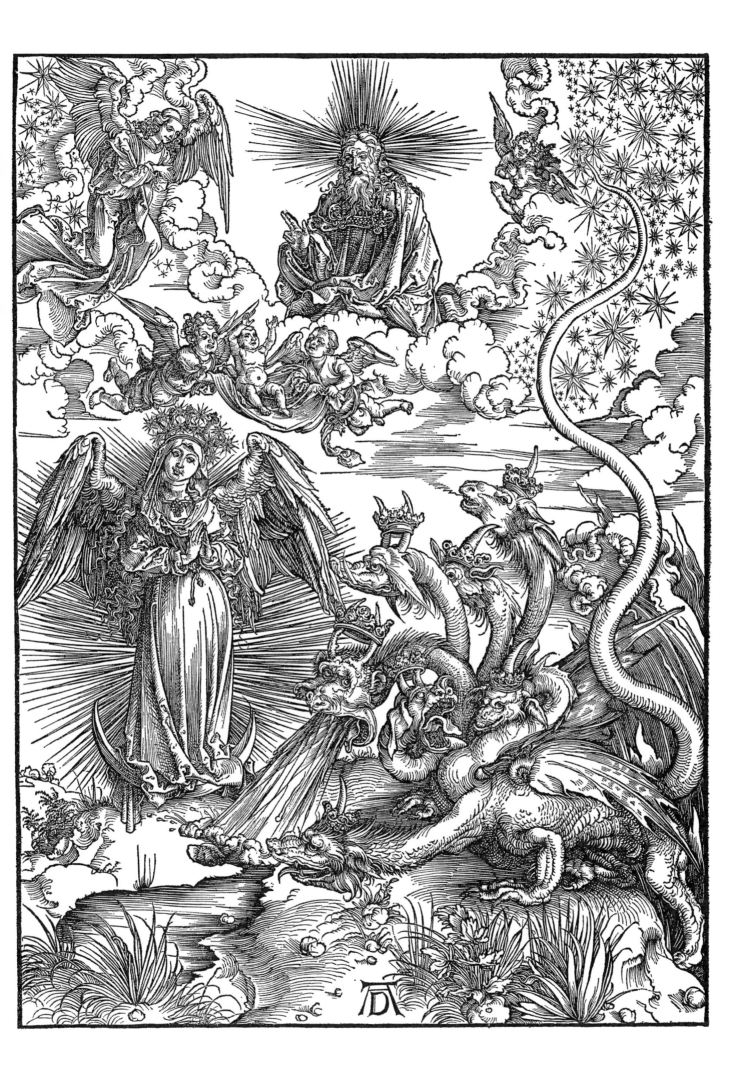

12. SAINT MICHAEL FIGHTING THE DRAGON

7 And there was war in heaven: Michael and his angels fought against the dragon;
and the dragon fought and his angels,
8 And prevailed not; neither was their place found any more in heaven.
9 And the great dragon was cast out, that old serpent, called the Devil, and Satan,
which deceiveth the whole world: he was cast out into the earth,
and his angels were cast out with him.
10 And I heard a loud voice saying in heaven, Now is come salvation, and strength,
and the kingdom of our God, and the power of his Christ: for the accuser of our
brethren is cast down, which accused them before our God day and night.
11 And they overcame him by the blood of the Lamb, and by the word of their
testimony; and they loved not their lives unto the death.
12 Therefore rejoice, ye heavens, and ye that dwell in them. Woe to the
inhabiters of the earth and of the sea! for the devil is come down unto you,
having great wrath, because he knoweth that he hath but a short time.

REVELATION, CHAPTER 12, VERSES 7-12

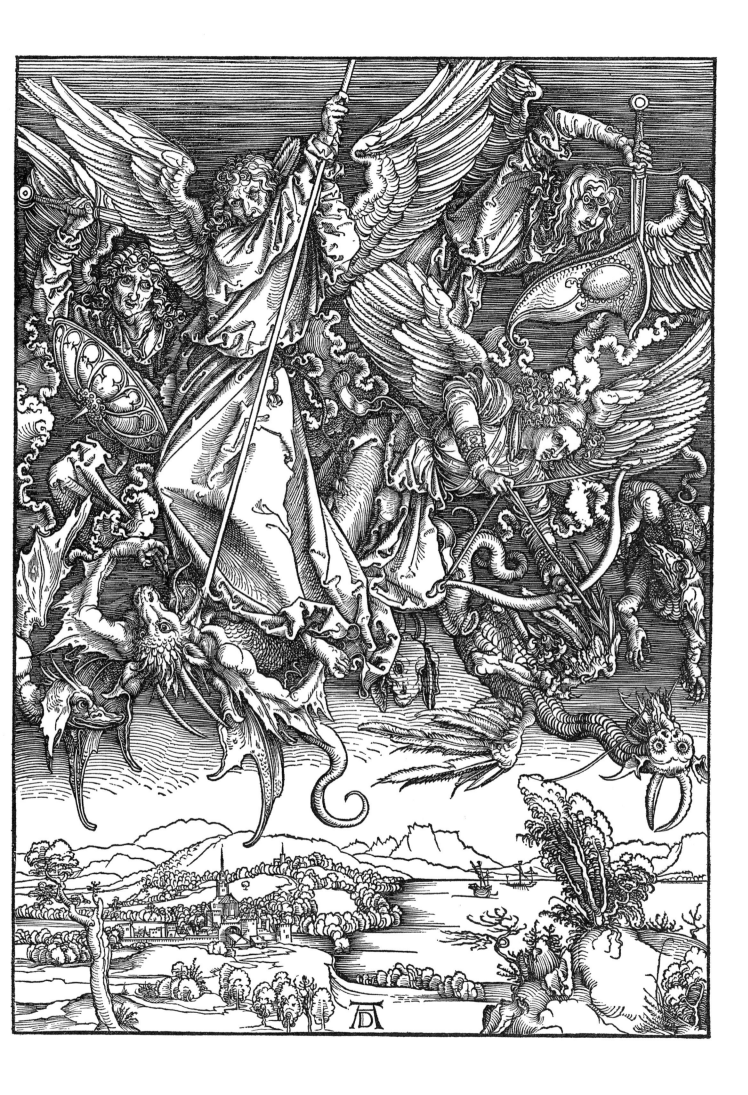

13. THE WHORE OF BABYLON

1 And there came one of the seven angels which had the seven vials, and talked with me,
saying unto me, Come hither; I will shew unto thee the judgment of
the great whore that sitteth upon many waters:
2 With whom the kings of the earth have committed fornication, and the inhabitants
of the earth have been made drunk with the wine of her fornication.
3 So he carried me away in the spirit into the wilderness: and I saw a woman sit upon a
scarlet coloured beast, full of names of blasphemy, having seven heads and ten horns.
4 And the woman was arrayed in purple and scarlet colour, and decked with
gold and precious stones and pearls, having a golden cup in her hand full
of abominations and filthiness of her fornication:
5 And upon her forehead was a name written, Mystery, Babylon The Great,
The Mother Of Harlots And Abominations Of The Earth.
6 And I saw the woman drunken with the blood of the saints, and with the blood of
the martyrs of Jesus: and when I saw her, I wondered with great admiration.
1 And after these things I saw another angel come down from heaven, having
great power; and the earth was lightened with his glory.
2 And he cried mightily with a strong voice, saying, Babylon the great is fallen,
is fallen, and is become the habitation of devils, and the hold of every foul spirit,
and a cage of every unclean and hateful bird.
3 For all nations have drunk of the wine of the wrath of her fornication, and the
kings of the earth have committed fornication with her, and the merchants
of the earth are waxed rich through the abundance of her delicacies.
4 And I heard another voice from heaven, saying, Come out of her, my people,
that ye be not partakers of her sins, and that ye receive not of her plagues.
5 For her sins have reached unto heaven, and God hath remembered her iniquities.
6 Reward her even as she rewarded you, and double unto her double according
to her works: in the cup which she hath filled fill to her double.
7 How much she hath glorified herself, and lived deliciously, so much torment
and sorrow give her: for she saith in her heart, I sit a queen,
and am no widow, and shall see no sorrow.
8 Therefore shall her plagues come in one day, death, and mourning, and famine; and
she shall be utterly burned with fire: for strong is the Lord God who judgeth her.
9 And the kings of the earth, who have committed fornication and lived deliciously with her,
shall bewail her, and lament for her, when they shall see the smoke of her burning,
10 Standing afar off for the fear of her torment, saying,
Alas, alas that great city Babylon, that mighty city! for in one hour is thy judgment come.

REVELATION, CHAPTER 17, VERSES 1-6, AND CHAPTER 18, VERSES 1-10

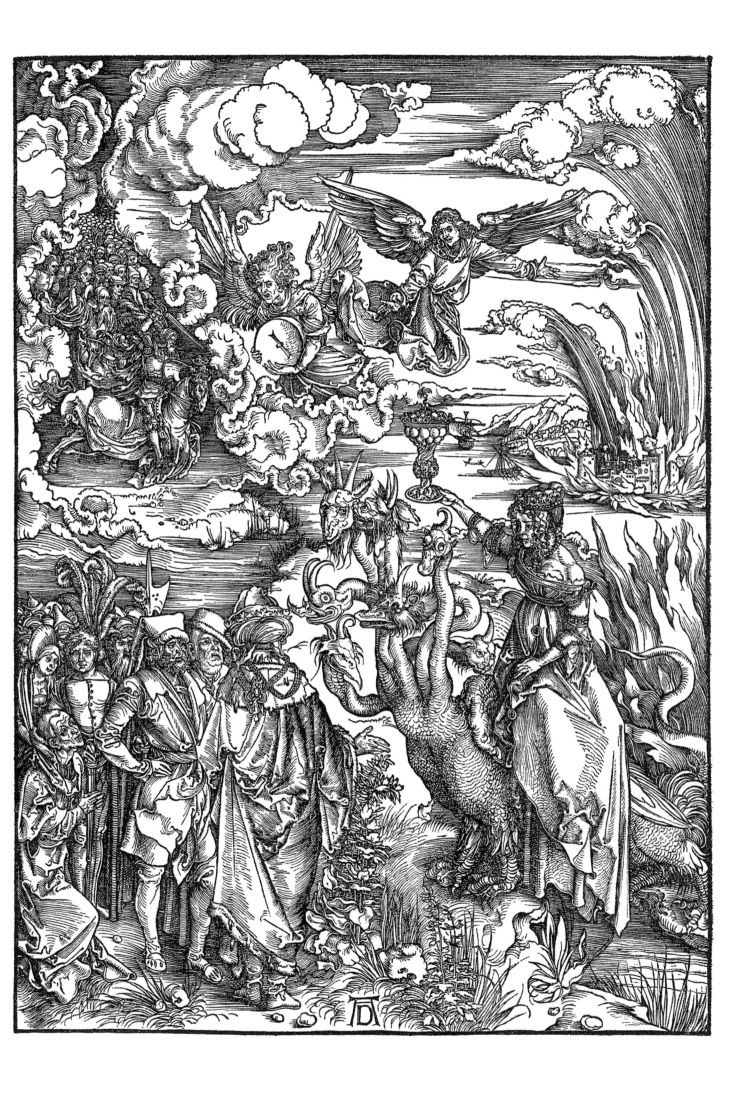

14. THE BEAST WITH THE LAMB'S HORNS AND THE BEAST WITH SEVEN HEADS

1 And I stood upon the sand of the sea, and saw a beast rise up out of the sea,
having seven heads and ten horns, and upon his horns ten crowns,
and upon his heads the name of blasphemy.
2 And the beast which I saw was like unto a leopard, and his feet were as the feet of
a bear, and his mouth as the mouth of a lion: and the dragon gave him
his power, and his seat, and great authority.
3 And I saw one of his heads as it were wounded to death; and his deadly wound
was healed: and all the world wondered after the beast.
4 And they worshipped the dragon which gave power unto the beast: and they worshipped
the beast, saying, Who is like unto the beast? who is able to make war with him?
5 And there was given unto him a mouth speaking great things and blasphemies;
and power was given unto him to continue forty and two months.
6 And he opened his mouth in blasphemy against God, to blaspheme his name,
and his tabernacle, and them that dwell in heaven.
7 And it was given unto him to make war with the saints, and to overcome them:
and power was given him over all kindreds, and tongues, and nations.
8 And all that dwell upon the earth shall worship him, whose names are not written
in the book of life of the Lamb slain from the foundation of the world.
9 If any man have an ear, let him hear.
10 He that leadeth into captivity shall go into captivity: he that killeth with the sword
must be killed with the sword. Here is the patience and the faith of the saints.
11 And I beheld another beast coming up out of the earth; and he had
two horns like a lamb, and he spake as a dragon.
12 And he exerciseth all the power of the first beast before him, and causeth the earth and
them which dwell therein to worship the first beast, whose deadly wound was healed.
13 And he doeth great wonders, so that he maketh fire come down
from heaven on the earth in the sight of men,
14 And deceiveth them that dwell on the earth by the means of those miracles which he had
power to do in the sight of the beast; saying to them that dwell on the earth, that they
should make an image to the beast, which had the wound by a sword, and did live.
15 And he had power to give life unto the image of the beast, that the image of
the beast should both speak, and cause that as many as would not worship
the image of the beast should be killed.
16 And he causeth all, both small and great, rich and poor, free and bond,
to receive a mark in their right hand, or in their foreheads:
17 And that no man might buy or sell, save he that had the mark, or the name
of the beast, or the number of his name.
18 Here is wisdom. Let him that hath understanding count the number of the beast:
for it is the number of a man; and his number is Six hundred threescore and six.

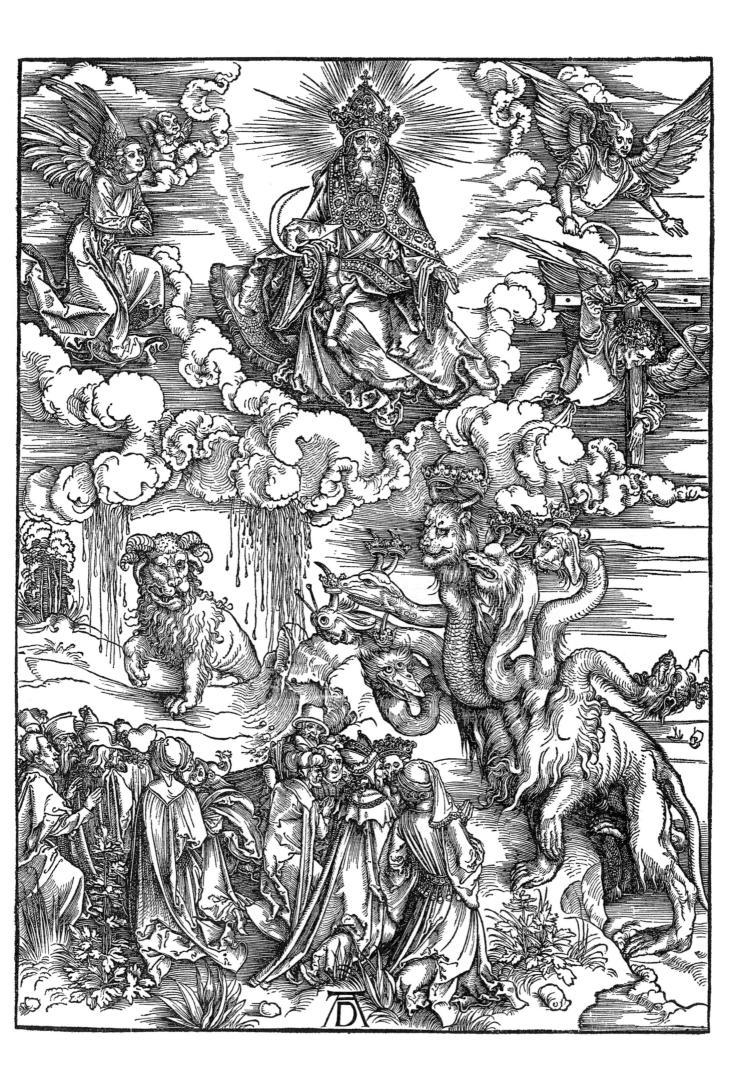

15. THE ANGEL WITH THE KEY OF THE BOTTOMLESS PIT

1 And I saw an angel come down from heaven, having the key of the
bottomless pit and a great chain in his hand.
2 And he laid hold on the dragon, that old serpent, which is the Devil, and Satan,
and bound him a thousand years,
3 And cast him into the bottomless pit, and shut him up, and set a seal upon him,
that he should deceive the nations no more, till the thousand years should be
fulfilled: and after that he must be loosed a little season.
9 And there came unto me one of the seven angels which had the seven vials
full of the seven last plagues, and talked with me, saying,
Come hither, I will shew thee the bride, the Lamb's wife.
10 And he carried me away in the spirit to a great and high mountain, and shewed
me that great city, the holy Jerusalem, descending out of heaven from God,
11 Having the glory of God: and her light was like unto a stone most precious,
even like a jasper stone, clear as crystal;
12 And had a wall great and high, and had twelve gates, and at the gates twelve
angels, and names written thereon, which are the names of the twelve tribes
of the children of Israel.
18 And the building of the wall of it was of jasper: and the city was pure gold,
like unto clear glass.
19 And the foundations of the wall of the city were garnished with all manner of
precious stones. The first foundation was jasper; the second, sapphire;
the third, a chalcedony; the fourth, an emerald;
20 The fifth, sardonyx; the sixth, sardius; the seventh, chrysolyte; the eighth, beryl;
the ninth, a topaz; the tenth, a chrysoprasus; the eleventh, a jacinth;
the twelfth, an amethyst.
21 And the twelve gates were twelve pearls: every several gate was of one pearl:
and the street of the city was pure gold, as it were transparent glass.
22 And I saw no temple therein: for the Lord God Almighty
and the Lamb are the temple of it.
23 And the city had no need of the sun, neither of the moon, to shine in it:
for the glory of God did lighten it, and the Lamb is the light thereof.
24 And the nations of them which are saved shall walk in the light of it:
and the kings of the earth do bring their glory and honour into it.
25 And the gates of it shall not be shut at all by day:
for there shall be no night there.

REVELATION, CHAPTER 20, VERSES 1-3, AND CHAPTER 21, VERSES 9-12 AND 18-25

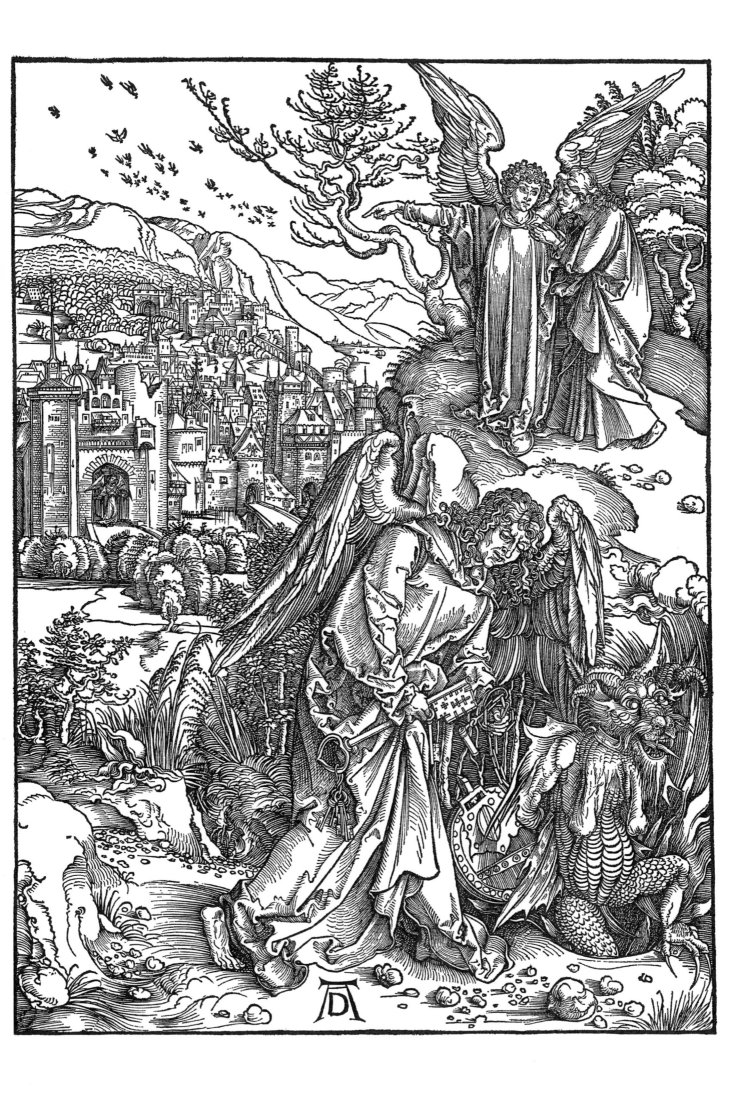

8 And I John saw these things, and heard them. And when I had heard
and seen, I fell down to worship before the feet of the angel
which shewed me these things.
9 Then saith he unto me, See thou do it not: for I am thy fellow-servant,
and of thy brethren the prophets, and of them which keep
the sayings of this book: worship God.
10 And he saith unto me, Seal not the sayings of the prophecy of this book:
for the time is at hand.
11 He that is unjust, let him be unjust still: and he which is filthy, let him be
filthy still: and he that is righteous, let him be righteous still:
and he that is holy, let him be holy still.
12 And, behold, I come quickly; and my reward is with me, to give
every man according as his work shall be.
13 I am Alpha and Omega, the beginning and the end,
the first and the last.
14 Blessed are they that do his commandments, that they may have right
to the tree of life, and may enter in through the gates into the city.
15 For without are dogs, and sorcerers, and whoremongers, and murderers,
and idolaters, and whosoever loveth and maketh a lie.
16 I Jesus have sent mine angel to testify unto you these things in the churches.
I am the root and the offspring of David, and the bright and morning star.
17 And the Spirit and the bride say, Come. And let him that heareth say,
Come. And let him that is athirst come. And whosoever will,
let him take the water of life freely.
18 For I testify unto every man that heareth the words of the prophecy of
this book, If any man shall add unto these things, God shall add
unto him the plagues that are written in this book:
19 And if any man shall take away from the words of the book of this prophecy,
God shall take away his part out of the book of life, and out of the holy city,
and from the things which are written in this book.
20 He which testifieth these things saith, Surely I come quickly. Amen.
Even so, come, Lord Jesus.
21 The grace of our Lord Jesus Christ be with you all. Amen.

REVELATION, CHAPTER 22, VERSES 8-21